Let Me KNOCK
That Off the Counter
for You

ULYSSES PRESS
PO Box 3440
Berkeley, CA 94703
www.ulyssespress.com

ISBN: 978-1-64604-556-3
Library of Congress Catalog Number: 2023938270

Printed in China

10 9 8 7 6 5 4 3 2 1

Acquisitions editor: Kierra Sondereker
Managing editor: Claire Chun
Proofreader: Barbara Schultz

Let Me KNOCK That Off the Counter for You

And More Everyday Sass from Cats

Photographs by Mark Rogers

ULYSSES PRESS

Good news! I found where
you stashed the catnip.

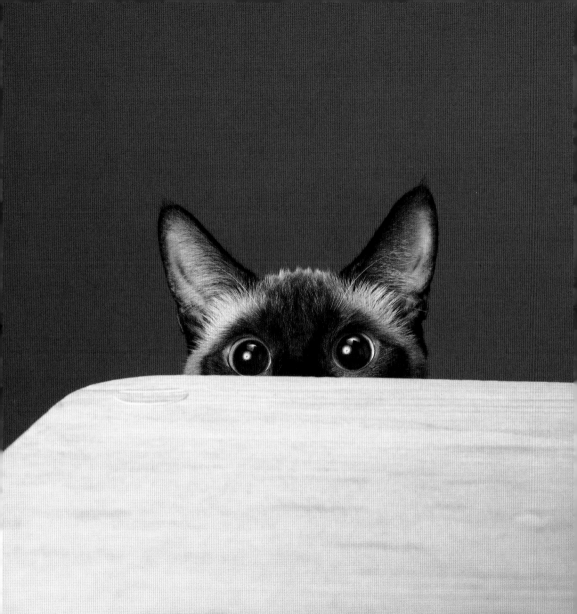

I'M DOING THIS FOR YOUR ENTERTAINMENT, NOT MINE.

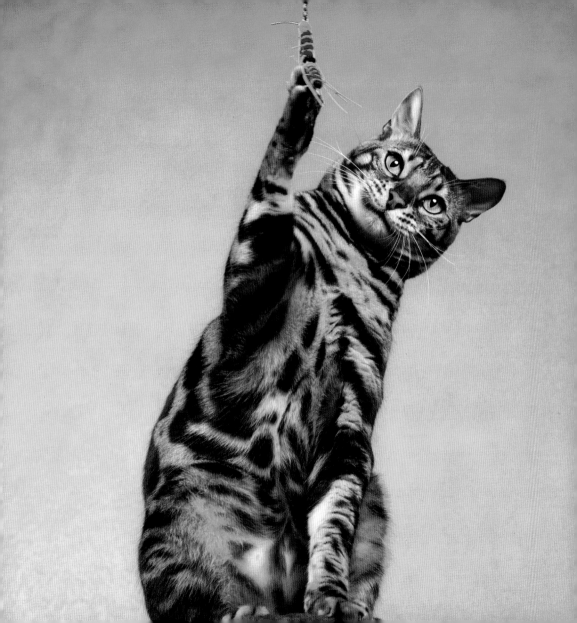

Know your place, human.

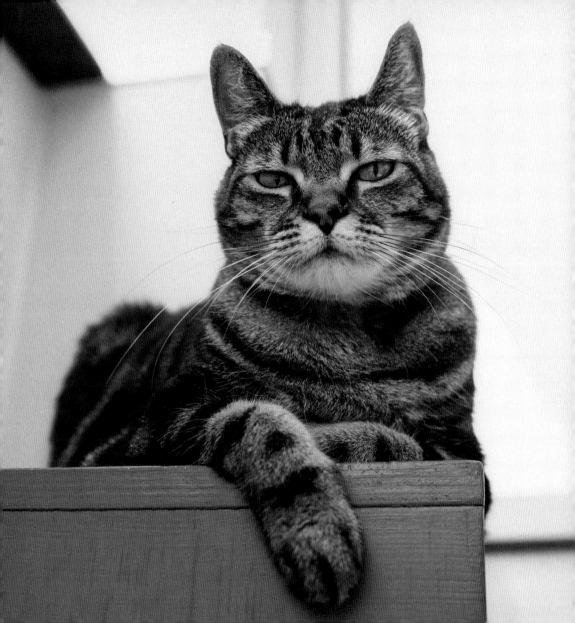

WHEN THE GOING GETS TOUGH, SIMPLY WALK AWAY.

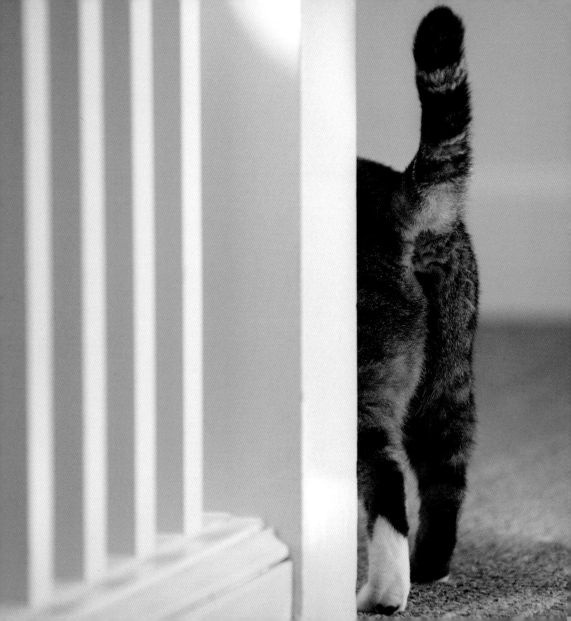

Sorry, this seat is taken.

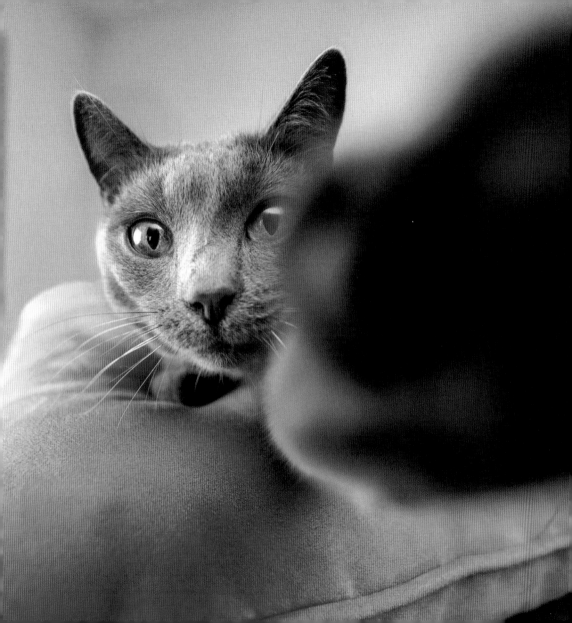

I'm watching you.
Always watching...

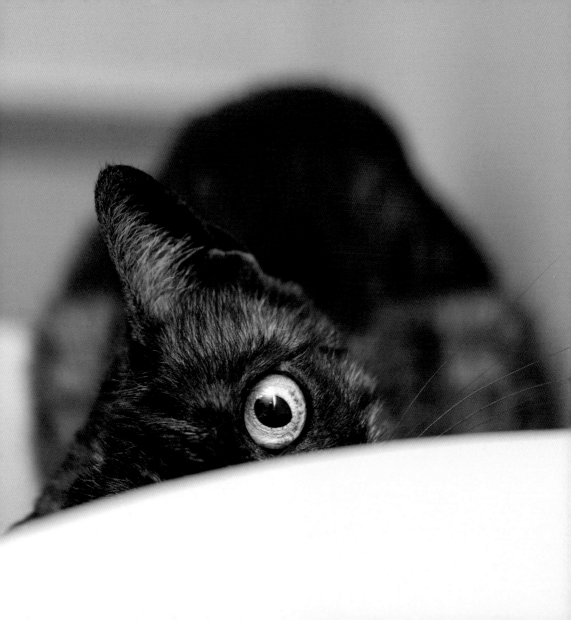

Yes, this looks like heaven.

No, you can't join.

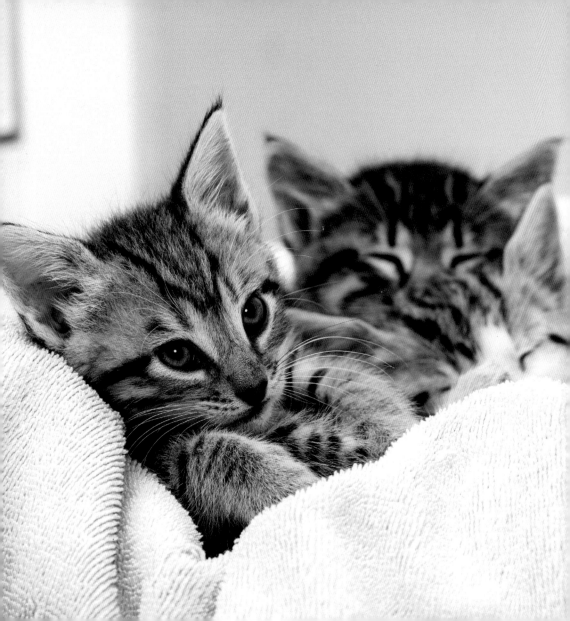

I BET THESE THINGS WILL WORK GREAT ON THE NEW COUCH.

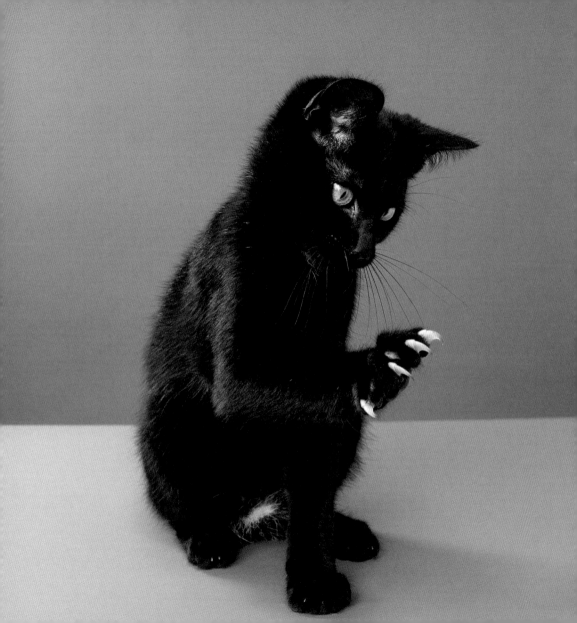

Just try getting me into this thing next Halloween when I'm not a kitten!

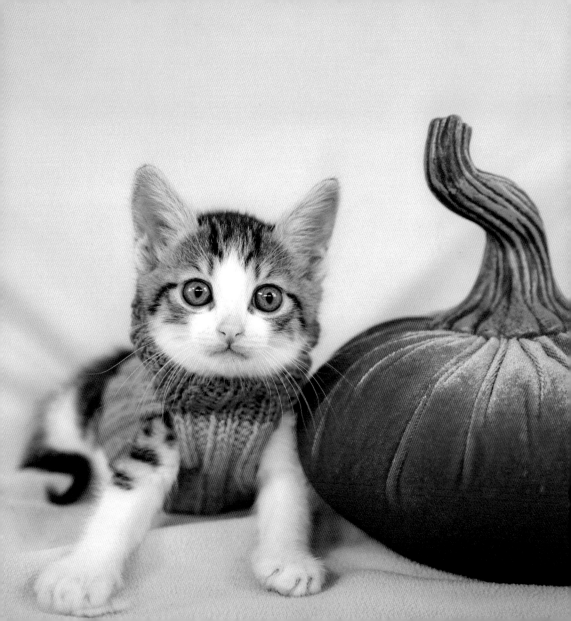

It's exhausting being the brains and the beauty in this family.

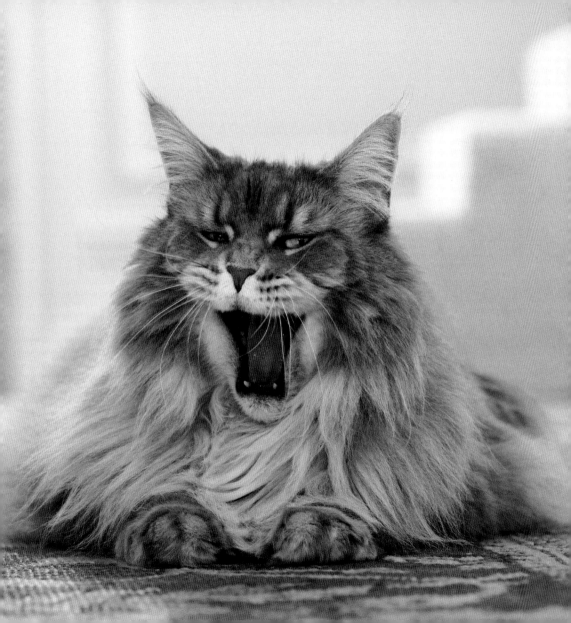

You've been summoned to explain why the bedroom door was closed all night despite my demands for entry.

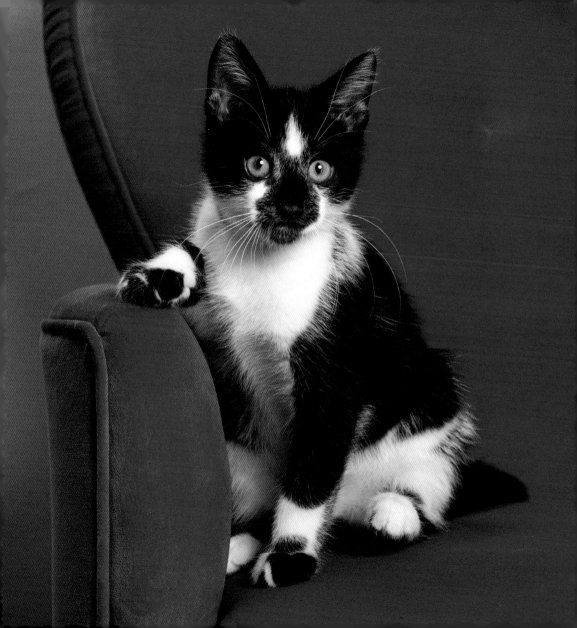

Remember to stop and $#%@ with the flowers.

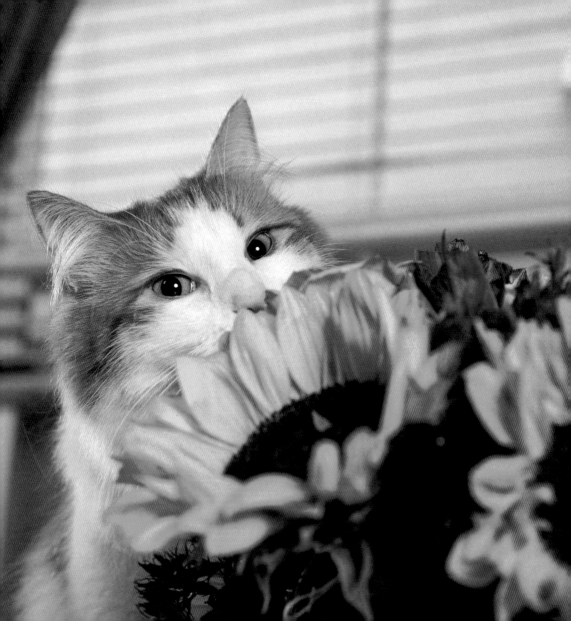

MY SECRETS TO SUCCESS?
1) ALWAYS LOOK RELAXED
AND INNOCENT.
2) BLAME THE DOG.

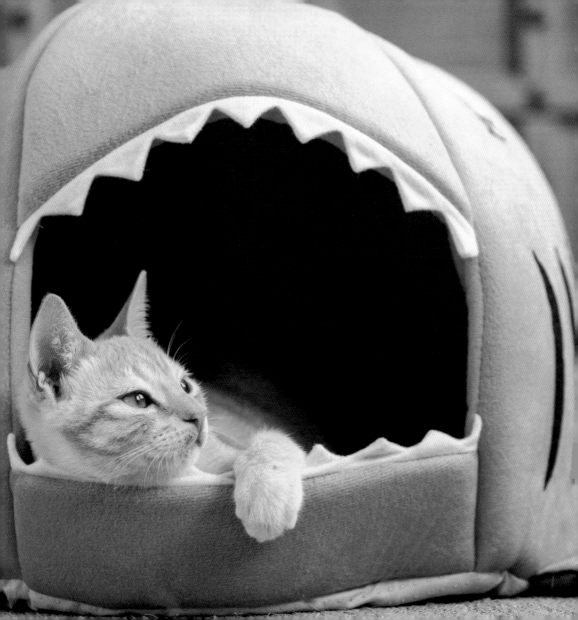

You touch the toe beans,
you turn on the crazy.

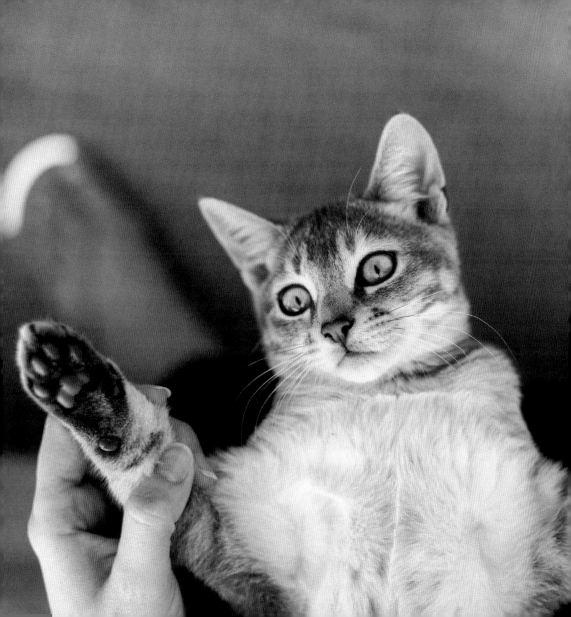

Your toothbrush tasted
a little funky today.

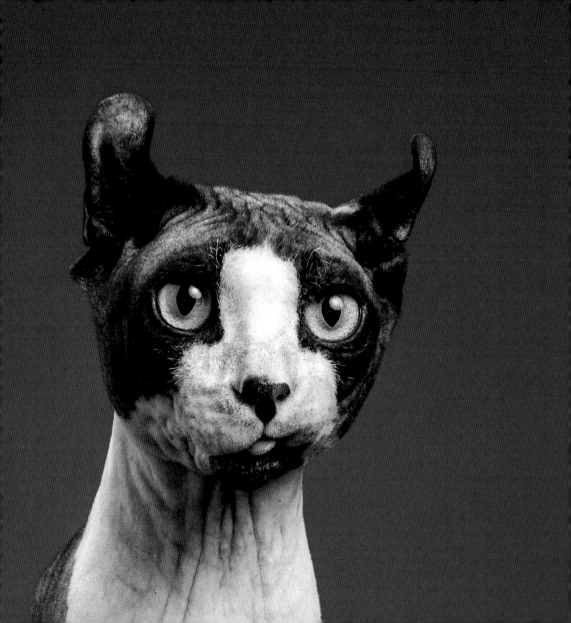

Give 'em the old
razzle-dazzle.

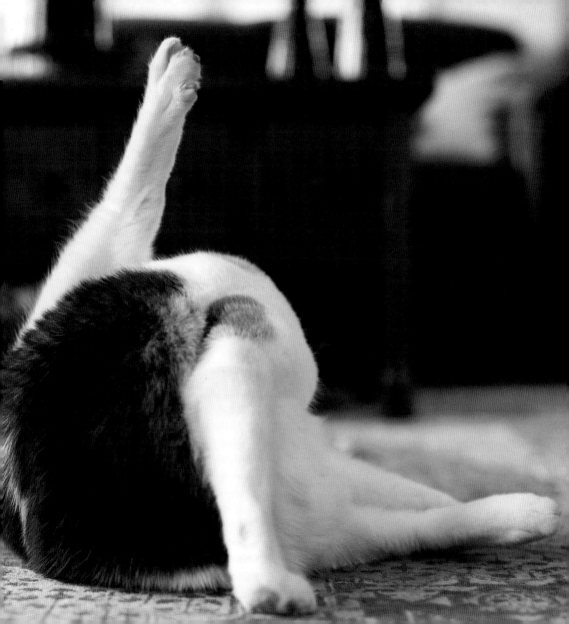

You seem to have forgotten the orders come from in here, not out there.

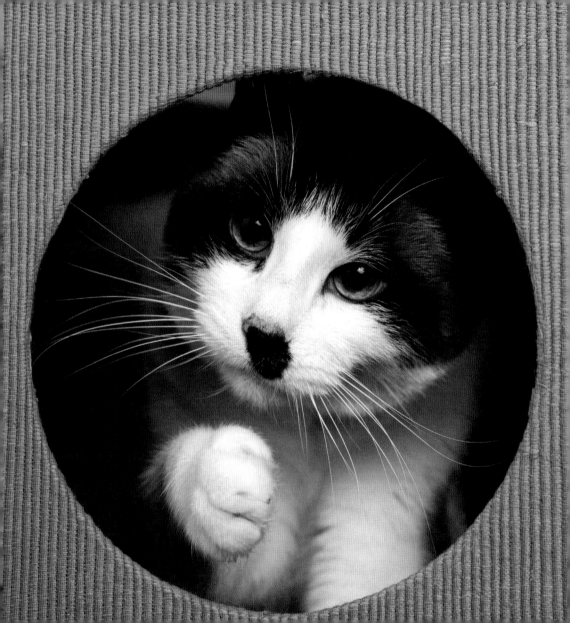

YOU KNOW, I ENJOY
WATCHING YOU SEARCH FOR
THIS UNDER THE COUCH
WAY MORE THAN YOU LIKE
WATCHING ME FETCH IT.

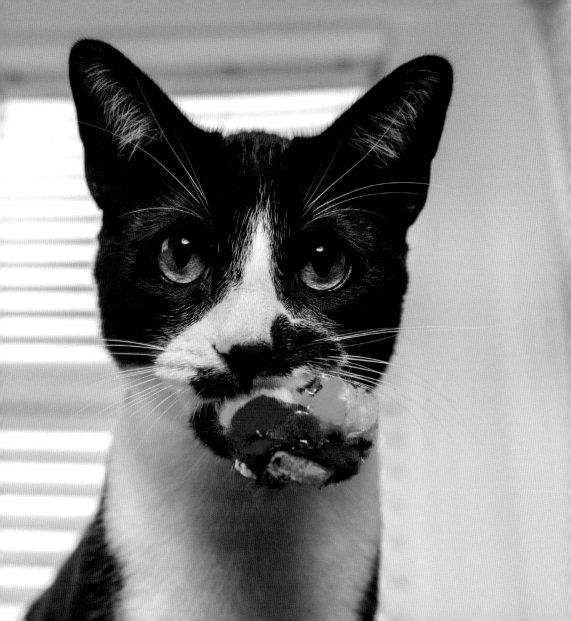

That's seriously what you're wearing?

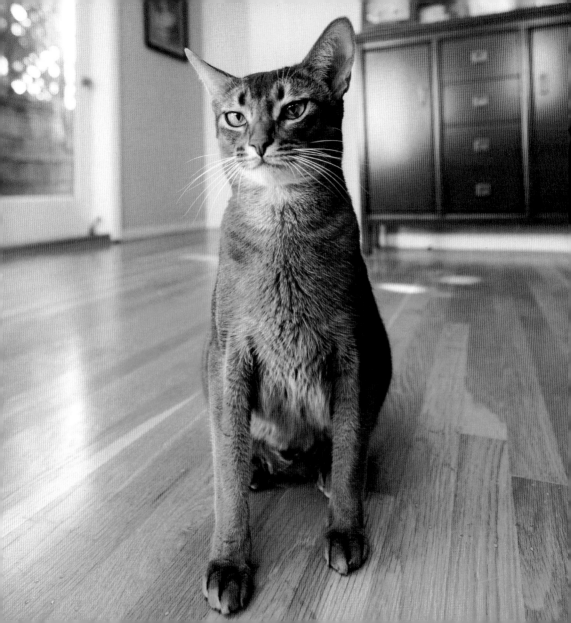

You left the ice cream out again. By the way, I prefer the butter pecan.

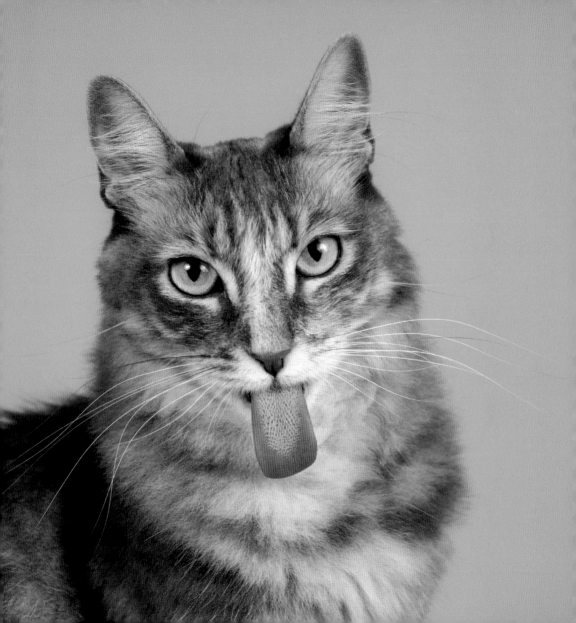

We both feel the quality of your service has been lacking of late.

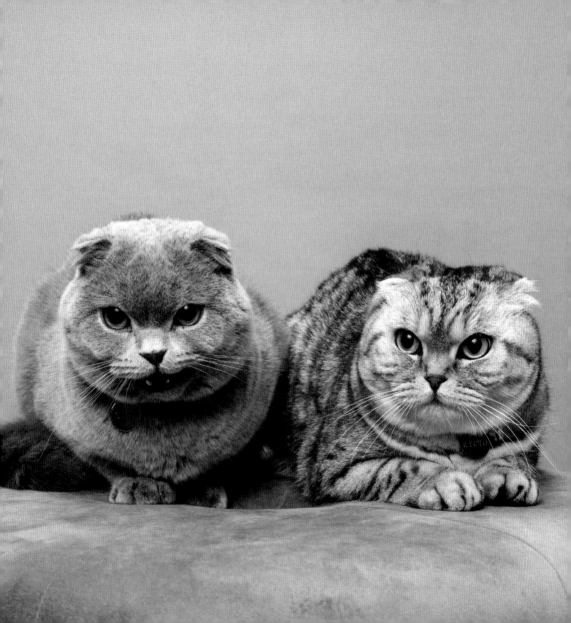

I wonder if you'll find it as amusing when I barf this up in your shoe.

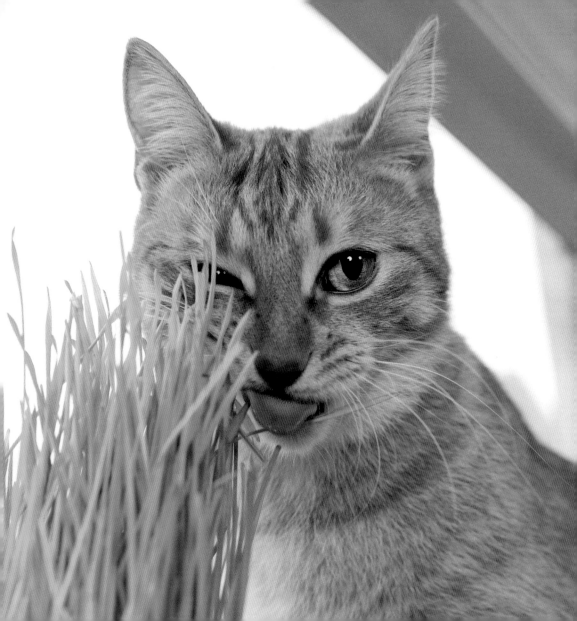

How can I look guilty
when I don't care if I did
something wrong?

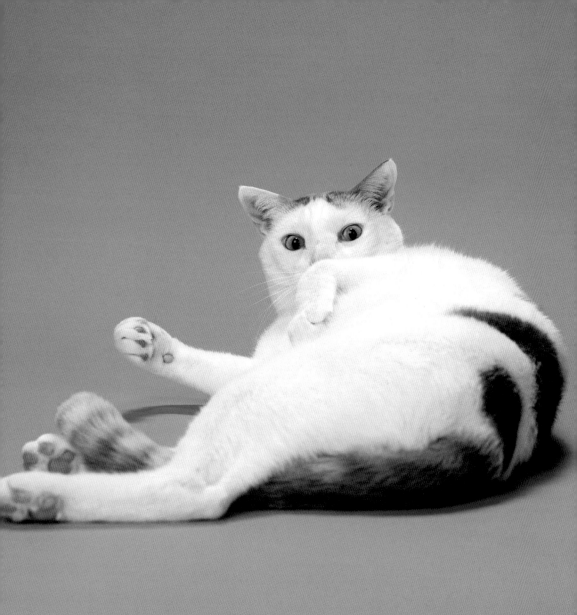

I'm sure you're wondering why I've gathered you here today.

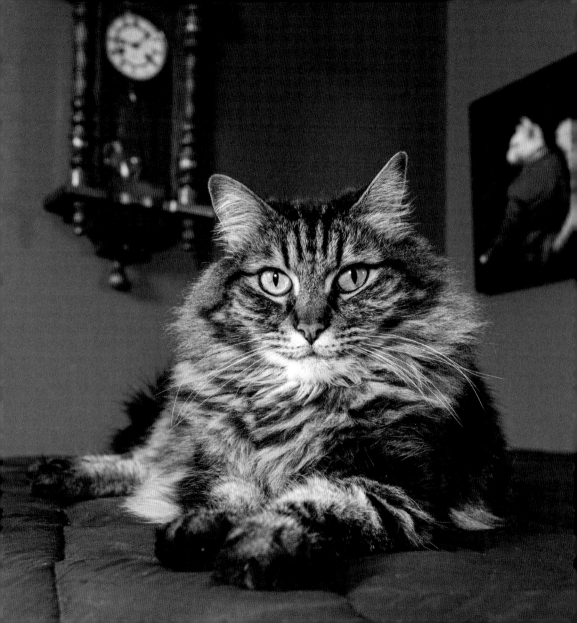

I'll stop sulking during parties as soon as you start running the guest list by me first.

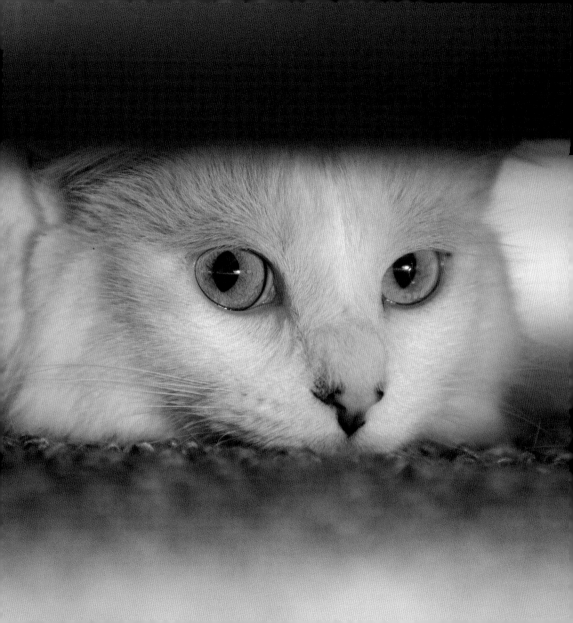

NO, YOU GO TO THE VET!

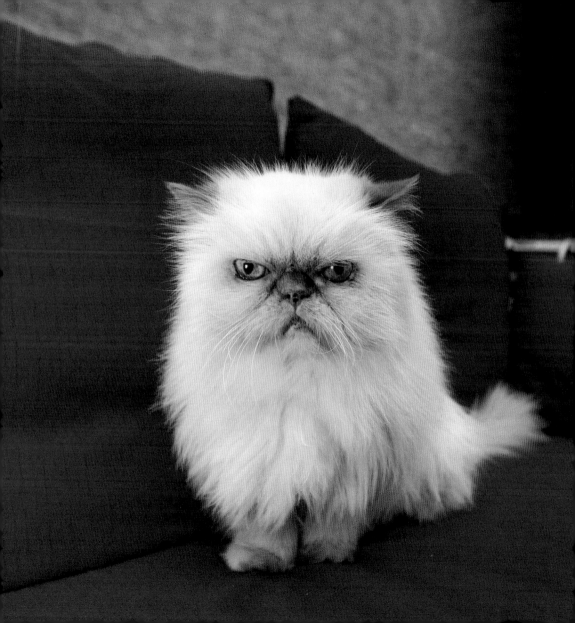

Telling me to hang in there will have consequences.

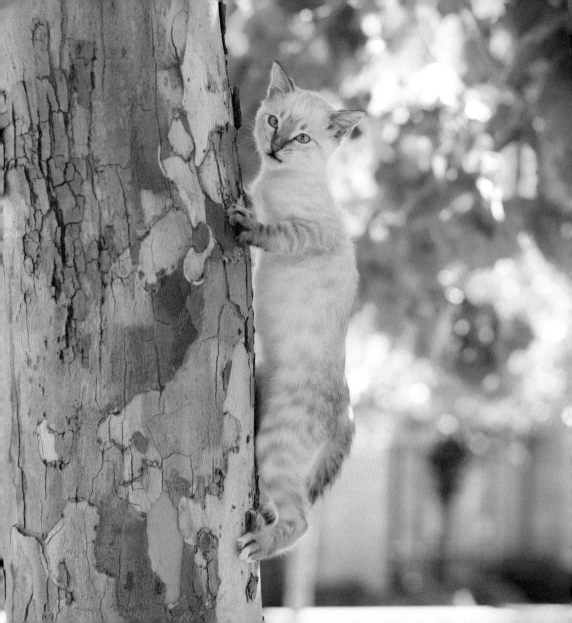

If I get the urge to do something nice, I lie down until it goes away.

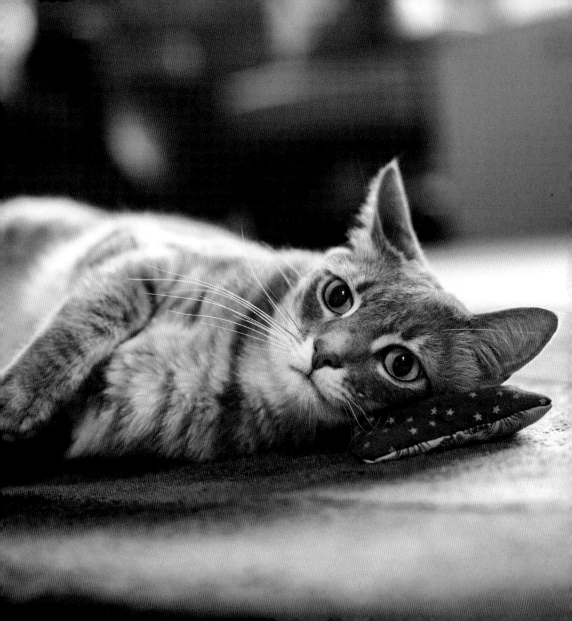

You say kitchen appliance,
I say furniture.

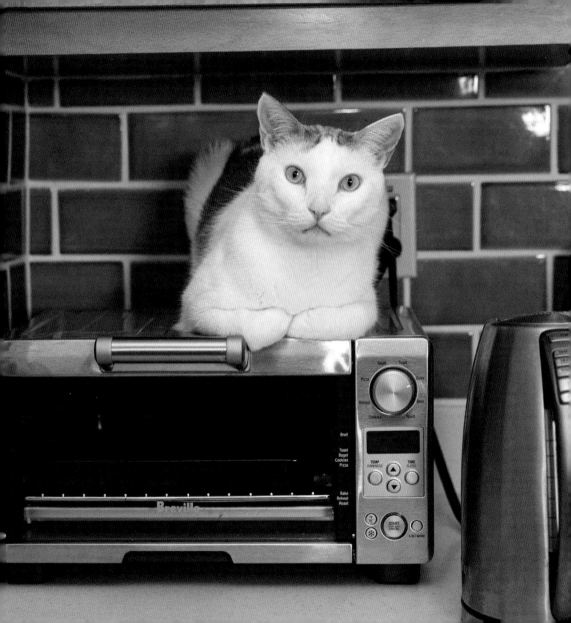

What's wrong with this toy? Nothing other than the color, shape, and size.

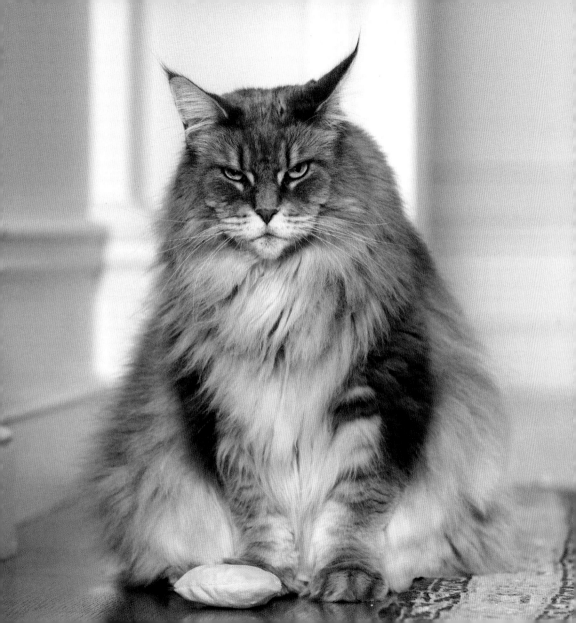

FROM THIS ANGLE, YOU ALMOST LOOK HAPPY WITH WHAT I DID TO THE CURTAINS.

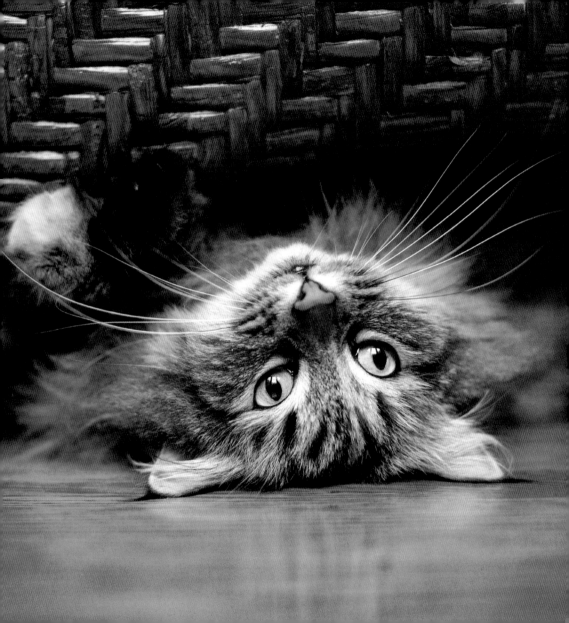

Yes, I will meow for 15 minutes straight. No, I don't want anything.

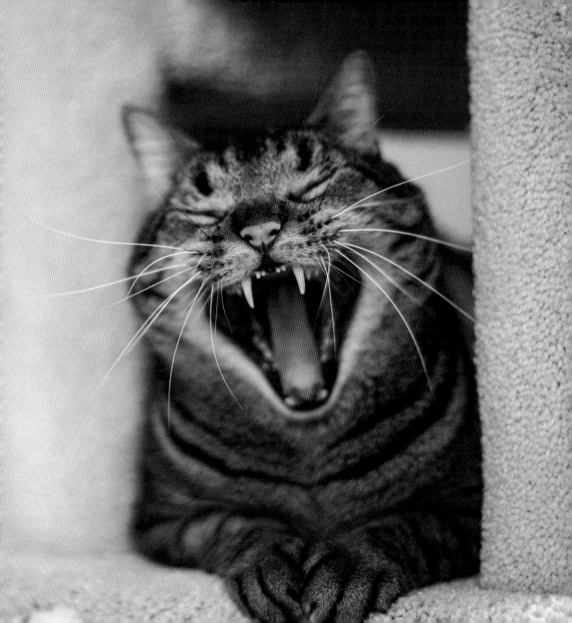

I came. I saw. I shredded.

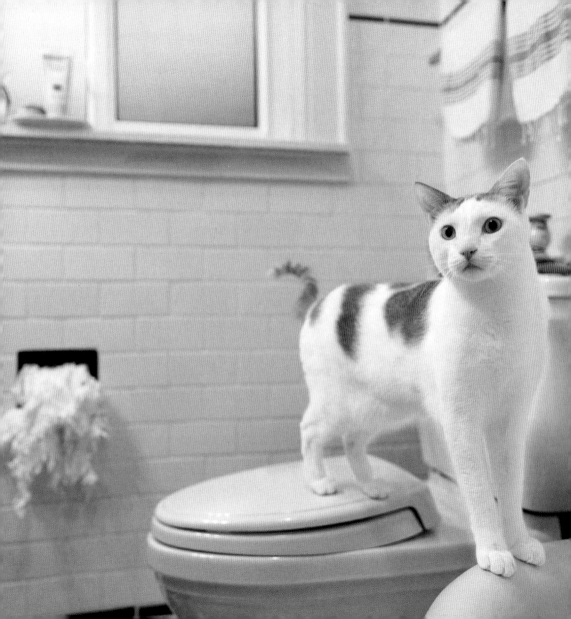

Really? You went all the way to Hawaii and brought me back this?

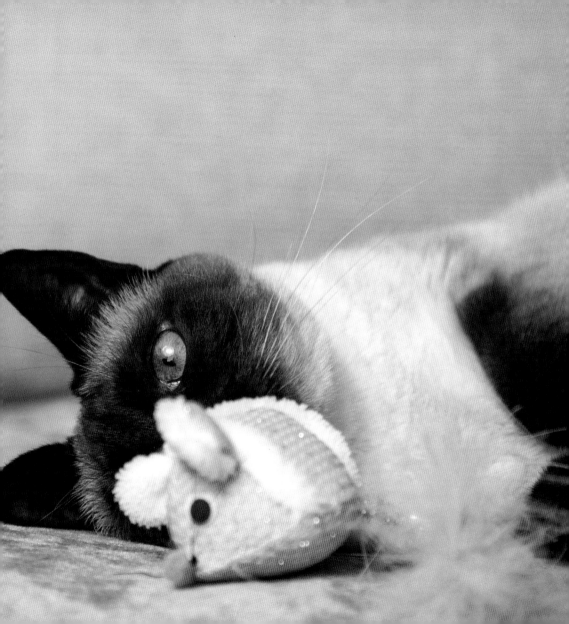

You seem to have forgotten who's really in charge here.

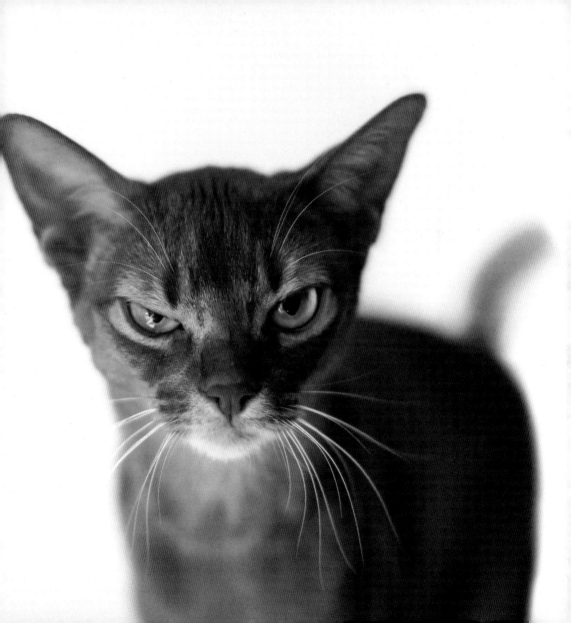

PRO TIP: EAR-PIERCING YOWLS
GET THEIR ATTENTION A
LOT FASTER THAN PURRS.

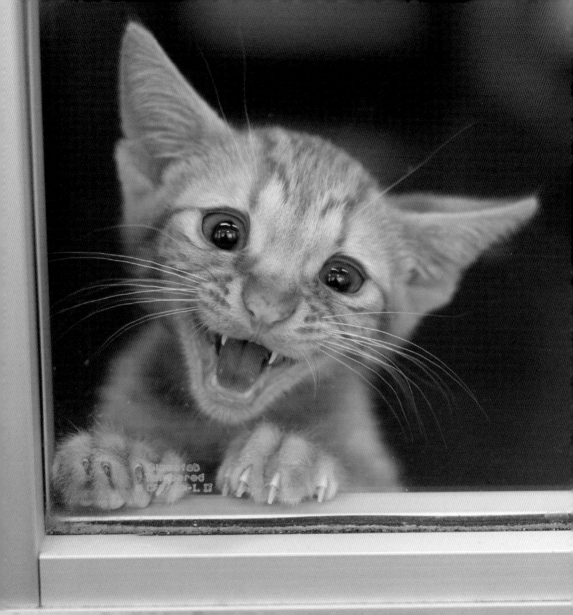

Me, surprised? Only that you still think this chair is yours.

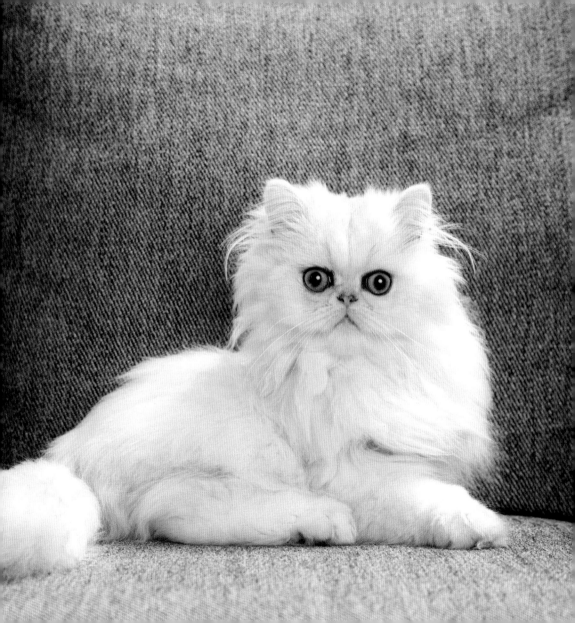

Send it back, I look better on tiger stripes.

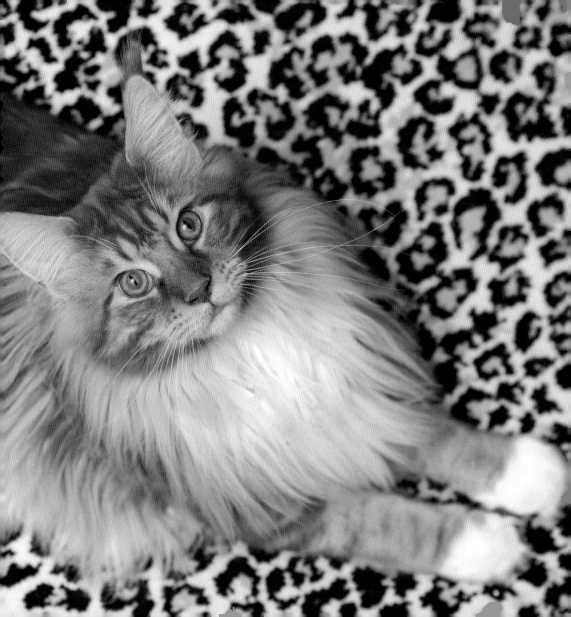

It's simple math, really.

One Belly Rub = Purrs.

Two Belly Rubs = Claws.

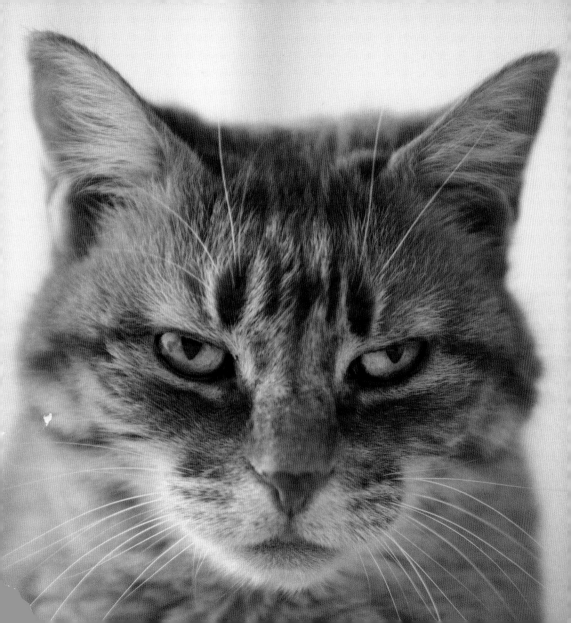

I learned how to take selfies on your phone and send them to your contact list.

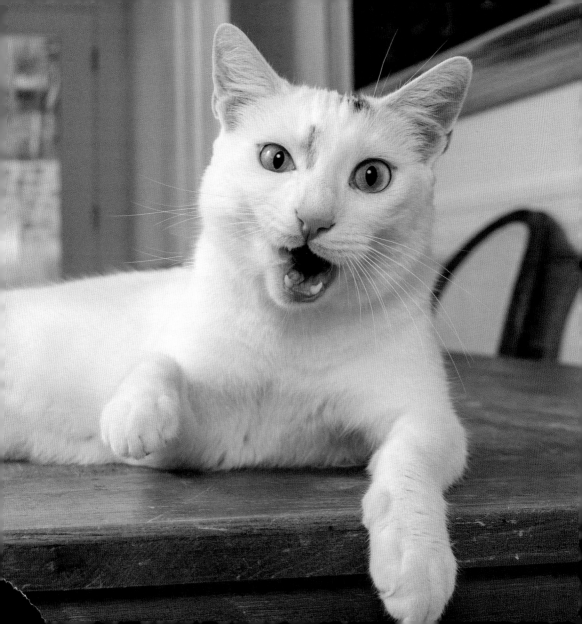

Oh this? I'm just stretching before I run around the entire house like I'm possessed.

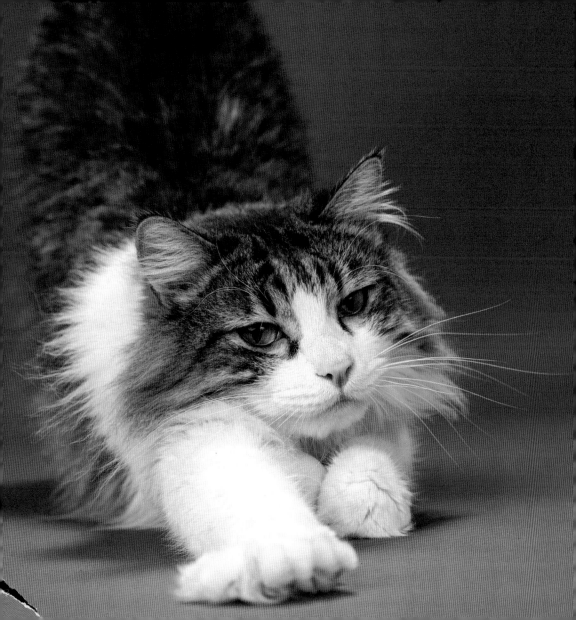

So many evil plans to
dream up, so little time.

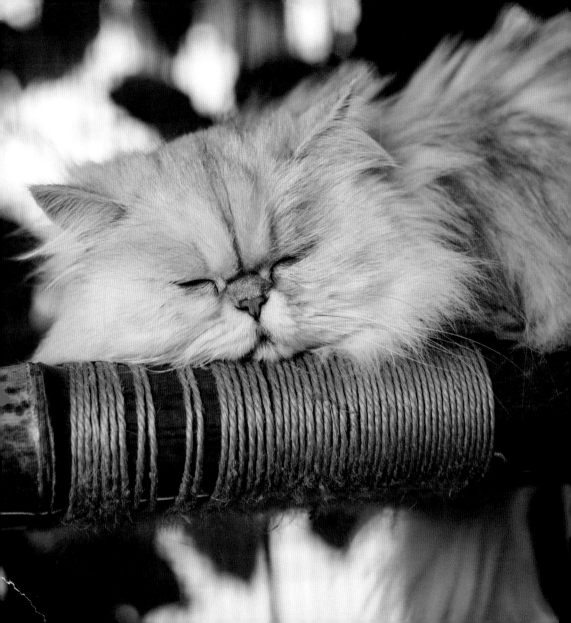

Paw prints on the butter?
Have you talked to the dog?

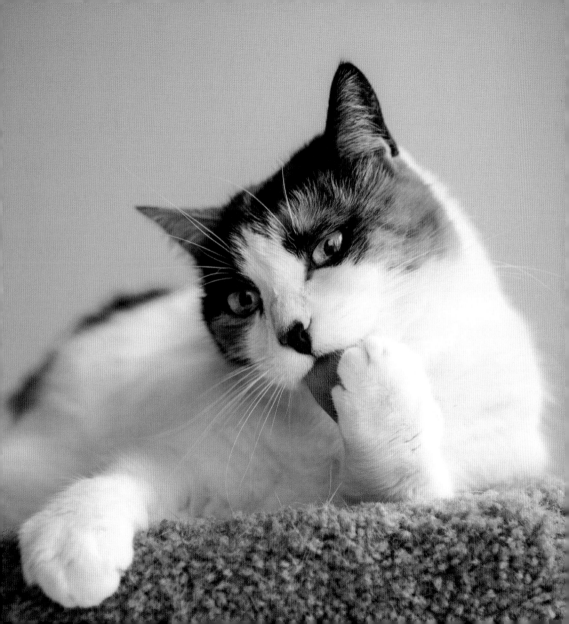

The bad news is we broke some things. The good news is there were lots of things to break!

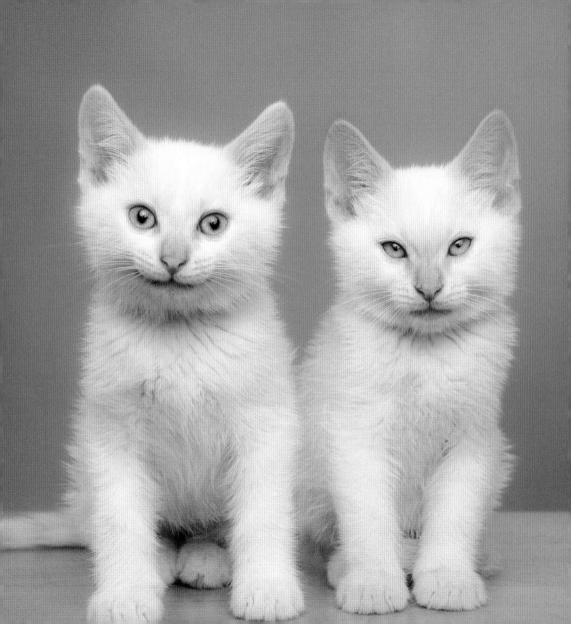

This is the part where you bow down.

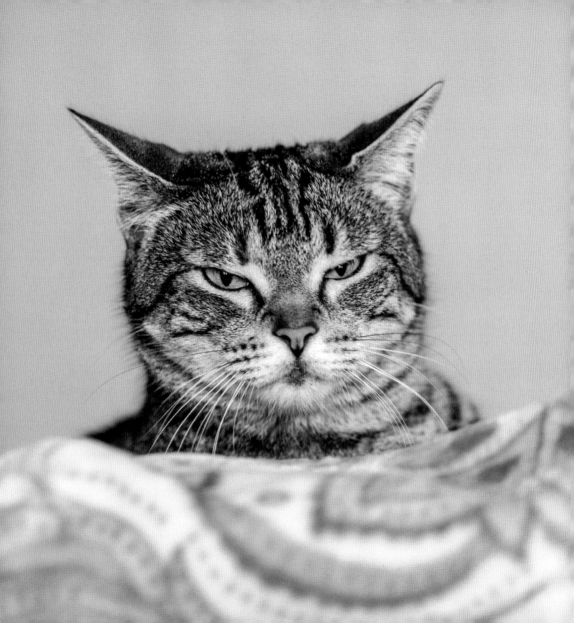

BELIEVE ME, YOU LOOK A LOT SILLIER WAVING THIS THING THAN I DO CATCHING IT.

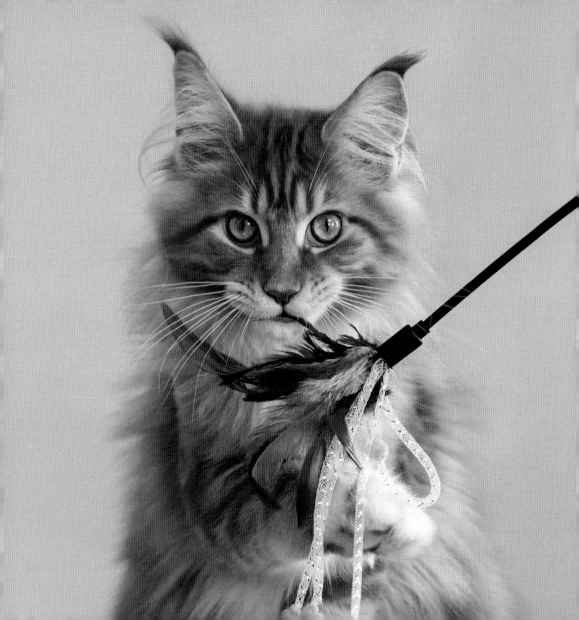

Always remember you're out-voted. On everything.

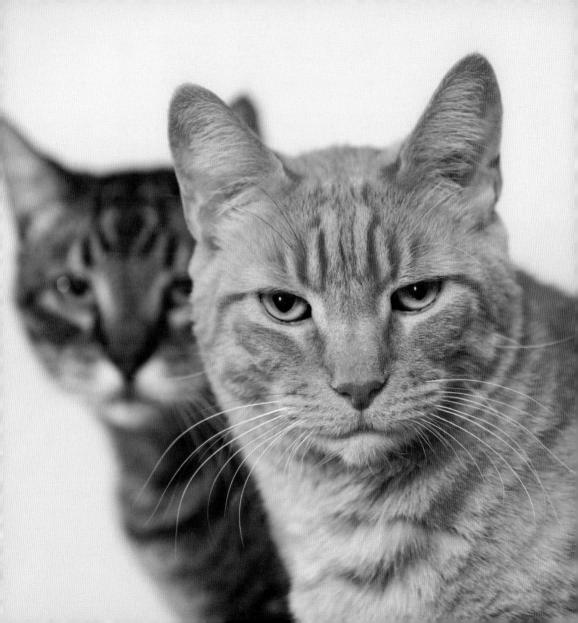

I may be in the backseat, but remember that makes you my chauffeur.

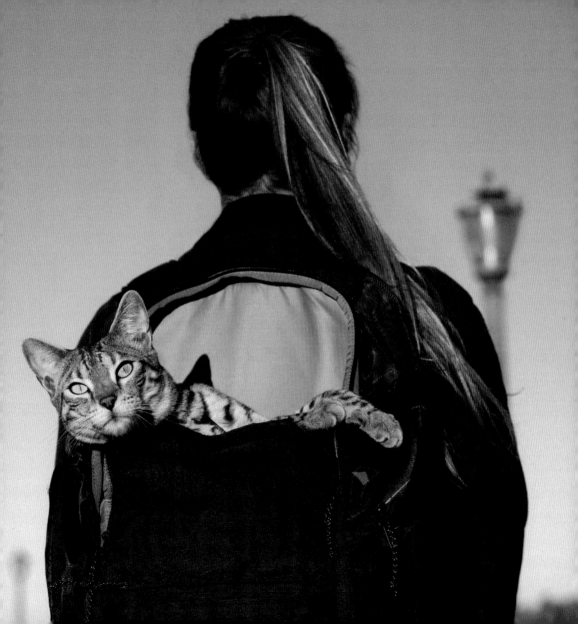

Hilarious.
What does your bowl say on it, "Waiter?"

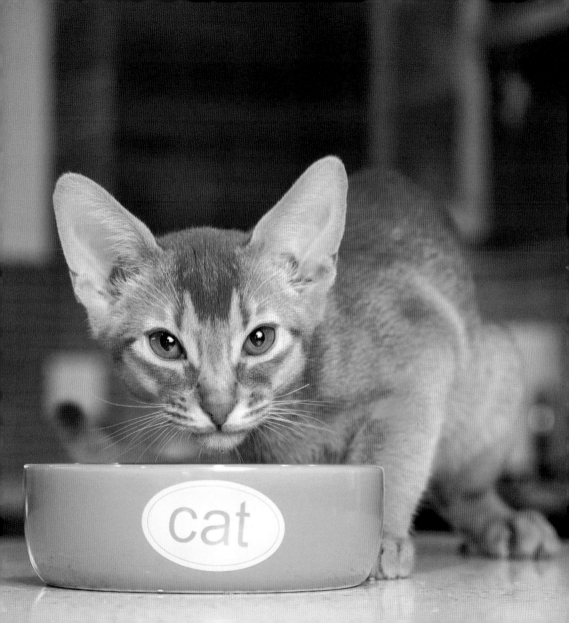

Contrary to popular belief, I do my best thinking inside the box.

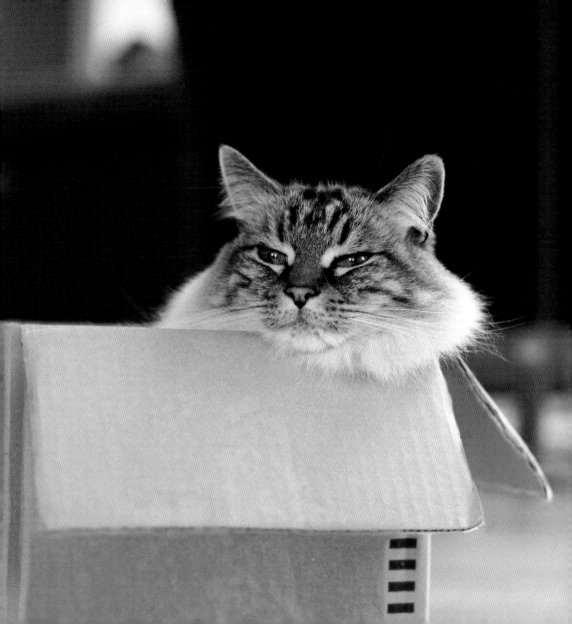

About the Photographer

Mark Rogers is a San Francisco pet photographer with the uncanny ability to capture the personalities and quirks of his animal subjects. He finds cats particularly fascinating and is pretty sure the internet was invented to distribute amusing videos of them. Mark's eye-catching, often humorous images of felines as well as dogs and other animals appear regularly in national advertising campaigns and print publications. He's also previously published several other books, including *Thanks for Picking Up My Poop: Everyday Gratitude from Dogs* and *Canines of San Francisco*.

Consistently selected as one of the Bay Area's top pet photographers, Mark is highly sought by private clients to work with their pets and donates much of his time to animal welfare and rescue groups.

Mark lives with his wife, Anne; his dog, Leeloo; and their cat, the diabolical Jimmy Chew (AKA James), who knows how to annoy each of them and does so frequently. James has reviewed and repeatedly edited sections of this book while sitting on Mark's keyboard.

You can see more of Mark's work at MarkRogersPhotography.com or visit him on Instagram @sf_dogphotog.